CAMERA QUEST

#31 DAY
Photography
CHALLENGE

By Margarita Brown
Sarah Janisse Brown
& Alexandra Bretush

FunSchooling.com

Name:

Date:

CONTENTS:

List of Books & Resources

Challenges:

LIST OF BOOKS & RESOURCES

My Favorite Books, Videos & Tutorials:

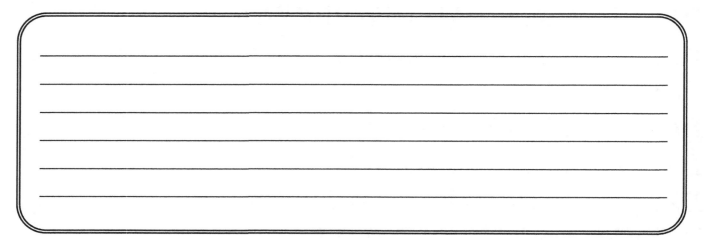

TAKE A PHOTO OF YOUR BOOKS AND TAPE IT HERE,
OR DRAW THE COVERS OF EACH BOOK:

About my Camera:

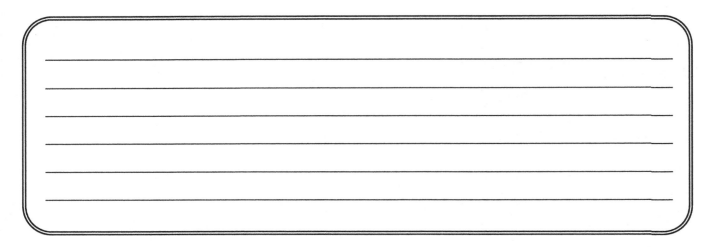

DAY#1
TAKE A PHOTO OF
A CUP OF TEA OR COFFEE

PRINT THE BEST PHOTO YOU
TOOK AND STICK IT HERE!

TAKE PHOTOS OF YOUR
DRINK INDOORS
AND OUTDOORS.

WHAT SETTINGS & FILTERS DID YOU USE FOR THIS PHOTO?

I Drew on it and added a border

WRITE ABOUT YOUR
EXPERIENCE TAKING/EDITING THIS PHOTO

it was fun and Eye opening

DESCRIBE THE LIGHT & COLORS IN YOUR PHOTO

DAY#2
TAKE A PHOTO OF YOUR FAVORITE BOOK

PRINT THE BEST PHOTO YOU
TOOK AND STICK IT HERE!

INVEST MORE TIME
IN LEARNING TECHNIQUE
DON'T FOCUS ON
EQUIPMENT

WHAT SETTINGS & FILTERS DID YOU USE FOR THIS PHOTO?

WRITE ABOUT YOUR
EXPERIENCE TAKING/EDITING THIS PHOTO

DESCRIBE THE LIGHT & COLORS IN YOUR PHOTO

DAY#3
TAKE A PHOTO OF YOUR FAMILY

PRINT THE BEST PHOTO YOU
TOOK AND STICK IT HERE!

USE NATURAL LIGHT.
TAKE PHOTOS IN THE
SHADE, IN THE SUN, AND
INSIDE BY A WINDOW.

WHAT SETTINGS & FILTERS DID YOU USE FOR THIS PHOTO?

WRITE ABOUT YOUR EXPERIENCE TAKING/EDITING THIS PHOTO

DESCRIBE THE LIGHT & COLORS IN YOUR PHOTO

DAY#4
TAKE A PHOTO OF A DESSERT

PRINT THE BEST PHOTO YOU TOOK AND STICK IT HERE!

LEARN EVERYTHING POSSIBLE ABOUT YOUR CAMERA, SETTINGS AND YOUR LENSES.

WHAT SETTINGS & FILTERS DID YOU USE FOR THIS PHOTO?

WRITE ABOUT YOUR
EXPERIENCE TAKING/EDITING THIS PHOTO

DESCRIBE THE LIGHT & COLORS IN YOUR PHOTO

DAY#5
TAKE A PHOTO OF A FLOWER

PRINT THE BEST PHOTO YOU
TOOK AND STICK IT HERE!

USE THE
"RULE OF THIRDS"
Look it up!

WHAT SETTINGS & FILTERS DID YOU USE FOR THIS PHOTO?

WRITE ABOUT YOUR
EXPERIENCE TAKING/EDITING THIS PHOTO

DESCRIBE THE LIGHT & COLORS IN YOUR PHOTO

DAY#6
TAKE A PHOTO OF BIRDS

PRINT THE BEST PHOTO YOU
TOOK AND STICK IT HERE!

PAY ATTENTION
TO THE LIGHT!

WHAT SETTINGS & FILTERS DID YOU USE FOR THIS PHOTO?

WRITE ABOUT YOUR
EXPERIENCE TAKING/EDITING THIS PHOTO

DESCRIBE THE LIGHT & COLORS IN YOUR PHOTO

DAY#7
TAKE A PORTRAIT OF A FRIEND

PRINT THE BEST PHOTO YOU
TOOK AND STICK IT HERE!

LEARN ABOUT
COLOR THEORY.

WHAT SETTINGS & FILTERS DID YOU USE FOR THIS PHOTO?

WRITE ABOUT YOUR EXPERIENCE TAKING/EDITING THIS PHOTO

DESCRIBE THE LIGHT & COLORS IN YOUR PHOTO

DAY#8
TAKE A PHOTO OF AN ANIMAL

PRINT THE BEST PHOTO YOU
TOOK AND STICK IT HERE!

TAKE A PHOTO FROM 2
FEET AWAY, 6 FEET AWAY,
AND 12 FEET AWAY.

WHAT SETTINGS & FILTERS DID YOU USE FOR THIS PHOTO?

WRITE ABOUT YOUR
EXPERIENCE TAKING/EDITING THIS PHOTO

DESCRIBE THE LIGHT & COLORS IN YOUR PHOTO

DAY#9
TAKE A PHOTO OF YOUR HOME

PRINT THE BEST PHOTO YOU
TOOK AND STICK IT HERE!

TAKE PHOTOS AT THREE
DIFFERENT TIMES OF DAY.
MORNING, NOON AND JUST
BEFORE SUNSET.

WHAT SETTINGS & FILTERS DID YOU USE FOR THIS PHOTO?

WRITE ABOUT YOUR
EXPERIENCE TAKING/EDITING THIS PHOTO

DESCRIBE THE LIGHT & COLORS IN YOUR PHOTO

DAY#10
TAKE A PHOTO OF YOUR
FAVORITE FRUIT

PRINT THE BEST PHOTO YOU
TOOK AND STICK IT HERE!

TAKE PHOTOS FROM
TEN DIFFERENT ANGLES!

WHAT SETTINGS & FILTERS DID YOU USE FOR THIS PHOTO?

WRITE ABOUT YOUR
EXPERIENCE TAKING/EDITING THIS PHOTO

DESCRIBE THE LIGHT & COLORS IN YOUR PHOTO

DAY#11
TAKE A PHOTO OF A LANDSCAPE

PRINT THE BEST PHOTO YOU
TOOK AND STICK IT HERE!

TAKE PICTURES AT THE
SAME LOCATION
AT TWO DIFFERENT TIMES
OF DAY.

WHAT SETTINGS & FILTERS DID YOU USE FOR THIS PHOTO?

WRITE ABOUT YOUR
EXPERIENCE TAKING/EDITING THIS PHOTO

DESCRIBE THE LIGHT & COLORS IN YOUR PHOTO

DAY#12
TAKE A PHOTO OF YOUR LUNCH

PRINT THE BEST PHOTO YOU
TOOK AND STICK IT HERE!

TRY TO ARRANGE THE
FOOD IN A FUNNY WAY.

WHAT SETTINGS & FILTERS DID YOU USE FOR THIS PHOTO?

WRITE ABOUT YOUR
EXPERIENCE TAKING/EDITING THIS PHOTO

DESCRIBE THE LIGHT & COLORS IN YOUR PHOTO

DAY#13
TAKE A PHOTO OF THE SUNSET

PRINT THE BEST PHOTO YOU
TOOK AND STICK IT HERE!

DEVELOP YOUR
PERSONAL STYLE.

WHAT SETTINGS & FILTERS DID YOU USE FOR THIS PHOTO?

WRITE ABOUT YOUR
EXPERIENCE TAKING/EDITING THIS PHOTO

DESCRIBE THE LIGHT & COLORS IN YOUR PHOTO

DAY#14
TAKE A PHOTO OF THE SUNRISE

PRINT THE BEST PHOTO YOU
TOOK AND STICK IT HERE!

BREAK THE RULES
AND BE CREATIVE.

WHAT SETTINGS & FILTERS DID YOU USE FOR THIS PHOTO?

WRITE ABOUT YOUR
EXPERIENCE TAKING/EDITING THIS PHOTO

DESCRIBE THE LIGHT & COLORS IN YOUR PHOTO

DAY#15
TAKE A PHOTO OF A COUPLE

PRINT THE BEST PHOTO YOU
TOOK AND STICK IT HERE!

STUDY SOME
MODELING POSES.

WHAT SETTINGS & FILTERS DID YOU USE FOR THIS PHOTO?

WRITE ABOUT YOUR
EXPERIENCE TAKING/EDITING THIS PHOTO

DESCRIBE THE LIGHT & COLORS IN YOUR PHOTO

DAY#16
TAKE A PHOTO OF SOMEONE RUNNING, JUMPING, FLIPPING, OR PLAYING A SPORT

PRINT THE BEST PHOTO YOU TOOK AND STICK IT HERE!

EXPIRIMENT WITH ISO, SHUTTER SPEED, AND APERTURE.

WHAT SETTINGS & FILTERS DID YOU USE FOR THIS PHOTO?

WRITE ABOUT YOUR
EXPERIENCE TAKING/EDITING THIS PHOTO

DESCRIBE THE LIGHT & COLORS IN YOUR PHOTO

DAY#17
TAKE A PHOTO OF A BUSY STREET

PRINT THE BEST PHOTO YOU
TOOK AND STICK IT HERE!

TAKE PHOTOS AT THREE
DIFFERENT TIMES OF
DAY. WHAT LIGHT WAS
YOUR FAVORITE?

WHAT SETTINGS & FILTERS DID YOU USE FOR THIS PHOTO?

WRITE ABOUT YOUR
EXPERIENCE TAKING/EDITING THIS PHOTO

DESCRIBE THE LIGHT & COLORS IN YOUR PHOTO

DAY#18
TAKE A PHOTO OF SOME STRANGERS

PRINT THE BEST PHOTO YOU
TOOK AND STICK IT HERE!

DON'T BE TOO OBVIOUS.
LET THE PEOPLE BE PART
OF THE SCENE..

WHAT SETTINGS & FILTERS DID YOU USE FOR THIS PHOTO?

WRITE ABOUT YOUR
EXPERIENCE TAKING/EDITING THIS PHOTO

DESCRIBE THE LIGHT & COLORS IN YOUR PHOTO

DAY#19
TAKE A PHOTO OF AN
OCEAN, RIVER, OR LAKE

PRINT THE BEST PHOTO YOU
TOOK AND STICK IT HERE!

TRY TAKING
PICTURES IN
GOLDEN HOUR.

WHAT SETTINGS & FILTERS DID YOU USE FOR THIS PHOTO?

WRITE ABOUT YOUR
EXPERIENCE TAKING/EDITING THIS PHOTO

DESCRIBE THE LIGHT & COLORS IN YOUR PHOTO

DAY#20
TAKE A PHOTO OF YOUR ROOM

PRINT THE BEST PHOTO YOU
TOOK AND STICK IT HERE!

TAKE A PHOTO BEFORE
YOUR CLEAN YOUR ROOM
AND AFTER YOU CLEAN
YOUR ROOM.

WHAT SETTINGS & FILTERS DID YOU USE FOR THIS PHOTO?

WRITE ABOUT YOUR
EXPERIENCE TAKING/EDITING THIS PHOTO

DESCRIBE THE LIGHT & COLORS IN YOUR PHOTO

DAY#21
TAKE A PHOTO OF THE SKY

PRiNT THE BEST PHOTO YOU
TOOK AND STiCK iT HERE!

IF YOU HAVE PANARAMA
MODE ON YOUR CAMERA
TRY IT OUT!

WHAT SETTINGS & FILTERS DID YOU USE FOR THIS PHOTO?

WRITE ABOUT YOUR
EXPERIENCE TAKING/EDITING THIS PHOTO

DESCRIBE THE LIGHT & COLORS IN YOUR PHOTO

DAY#22
TAKE A PHOTO IN THE RAIN
(You can save this page for a rainy day)

PRINT THE BEST PHOTO YOU
TOOK AND STICK IT HERE!

LEARN TO PROTECT YOUR
GEAR FROM WATER.
TRY TO PHOTOGRAPH
REFLECTIONS IN
CREATIVE WAYS.

WHAT SETTINGS & FILTERS DID YOU USE FOR THIS PHOTO?

WRITE ABOUT YOUR
EXPERIENCE TAKING/EDITING THIS PHOTO

DESCRIBE THE LIGHT & COLORS IN YOUR PHOTO

DAY#23
TAKE A PHOTO OF NATURE

PRINT THE BEST PHOTO YOU
TOOK AND STICK IT HERE!

TAKE A PHOTO OF THE
SAME PIECE OF NATURE
FROM 5 DIFFERENT
DISTANCES.

WHAT SETTINGS & FILTERS DID YOU USE FOR THIS PHOTO?

WRITE ABOUT YOUR
EXPERIENCE TAKING/EDITING THIS PHOTO

DESCRIBE THE LIGHT & COLORS IN YOUR PHOTO

DAY#24
TAKE A PHOTO OF
A MUSICAL INSTRUMENT

PRINT THE BEST PHOTO YOU
TOOK AND STICK IT HERE!

SEEK ADVICE FROM
EXPERIENCED
PHOTOGRAPHERS.

WHAT SETTINGS & FILTERS DID YOU USE FOR THIS PHOTO?

WRITE ABOUT YOUR
EXPERIENCE TAKING/EDITING THIS PHOTO

DESCRIBE THE LIGHT & COLORS IN YOUR PHOTO

DAY#25
TAKE A PHOTO OF SOMETHING OLD

PRINT THE BEST PHOTO YOU
TOOK AND STICK IT HERE!

LIMIT YOUR
COLOR PALETTE. TO ONLY
THREE COLORS.

WHAT SETTINGS & FILTERS DID YOU USE FOR THIS PHOTO?

WRITE ABOUT YOUR
EXPERIENCE TAKING/EDITING THIS PHOTO

DESCRIBE THE LIGHT & COLORS IN YOUR PHOTO

DAY#26
TAKE A PHOTO OF A CAR

PRINT THE BEST PHOTO YOU
TOOK AND STICK IT HERE!

LEARN ALL YOU
CAN ABOUT POST
PRODUCTION.

WHAT SETTINGS & FILTERS DID YOU USE FOR THIS PHOTO?

WRITE ABOUT YOUR
EXPERIENCE TAKING/EDITING THIS PHOTO

DESCRIBE THE LIGHT & COLORS IN YOUR PHOTO

DAY#27
TAKE A PHOTO OF A TREE

PRINT THE BEST PHOTO YOU
TOOK AND STICK IT HERE!

TRY TAKING PICTURES
IN BLUE HOUR.

WHAT SETTINGS & FILTERS DID YOU USE FOR THIS PHOTO?

WRITE ABOUT YOUR
EXPERIENCE TAKING/EDITING THIS PHOTO

DESCRIBE THE LIGHT & COLORS IN YOUR PHOTO

DAY#28
TAKE A PHOTO OF AN OLD BUILDING

PRINT THE BEST PHOTO YOU
TOOK AND STICK IT HERE!

LEARN HOW TO
TAKE GOOD CARE
OF YOUR LENS.

WHAT SETTINGS & FILTERS DID YOU USE FOR THIS PHOTO?

WRITE ABOUT YOUR
EXPERIENCE TAKING/EDITING THIS PHOTO

DESCRIBE THE LIGHT & COLORS IN YOUR PHOTO

DAY#29
TAKE A PHOTO OF YOUR FAVORITE PLACE

PRINT THE BEST PHOTO YOU TOOK AND STICK IT HERE!

STUDY
WHITE BALANCE.

WHAT SETTINGS & FILTERS DID YOU USE FOR THIS PHOTO?

WRITE ABOUT YOUR
EXPERIENCE TAKING/EDITING THIS PHOTO

DESCRIBE THE LIGHT & COLORS IN YOUR PHOTO

DAY#30
TAKE A PORTRAIT A PERSON AT WORK

PRINT THE BEST PHOTO YOU
TOOK AND STICK IT HERE!

FOCUSE
ON THE EYES.

WHAT SETTINGS & FILTERS DID YOU USE FOR THIS PHOTO?

WRITE ABOUT YOUR
EXPERIENCE TAKING/EDITING THIS PHOTO

DESCRIBE THE LIGHT & COLORS IN YOUR PHOTO

DAY#31
TAKE A PHOTO OF A RURAL ROAD

PRINT THE BEST PHOTO YOU
TOOK AND STICK IT HERE!

GET AN EXTERNAL HARD
DRIVE AND MAKE SURE TO
BACK UP YOUR PHOTOS.

WHAT SETTINGS & FILTERS DID YOU USE FOR THIS PHOTO?

WRITE ABOUT YOUR
EXPERIENCE TAKING/EDITING THIS PHOTO

DESCRIBE THE LIGHT & COLORS IN YOUR PHOTO

Made in the USA
Middletown, DE
13 June 2020